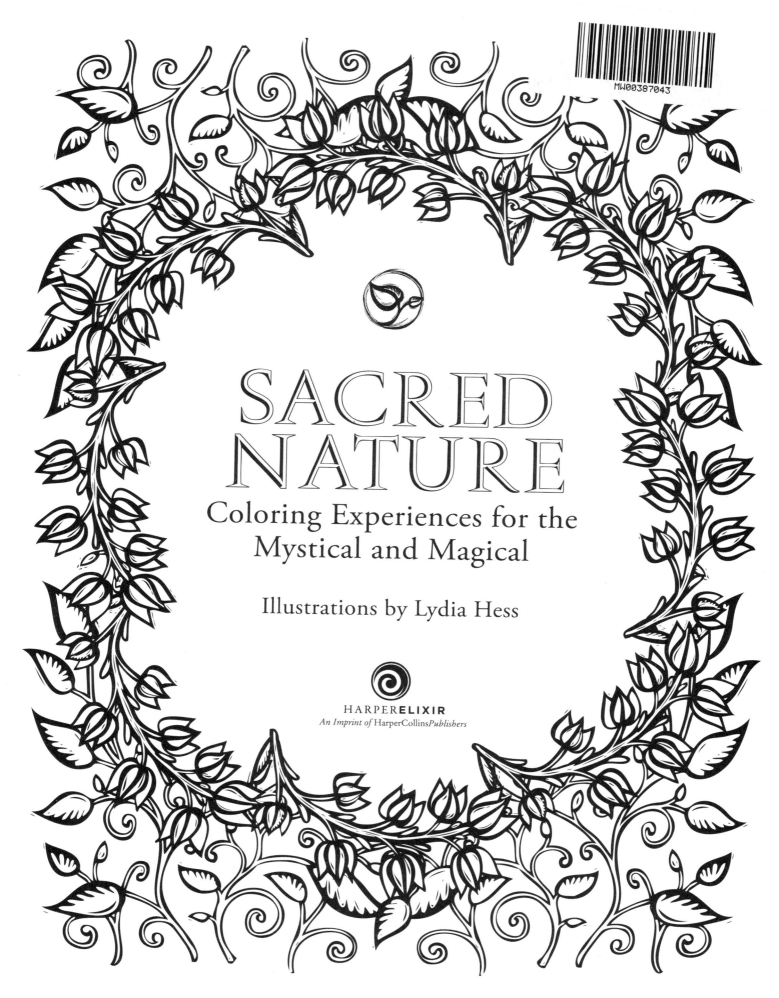

SACRED NATURE

Coloring Experiences for the Mystical and Magical

Illustrations by Lydia Hess

HARPER**ELIXIR**
An Imprint of HarperCollinsPublishers

HarperCollins books may be purchased for educational, business, or sales promotional use. For information please e-mail the Special Markets Department at SPsales@harpercollins.com.

HarperCollins website: http://www.harpercollins.com

FIRST EDITION •

Designed by Lydia Hess

Library of Congress Cataloging-in-Publication Data is available upon request.
ISBN 978–0–06–243438-8

15 16 17 18 19 RRD(H) 10 9 8 7 6 5 4

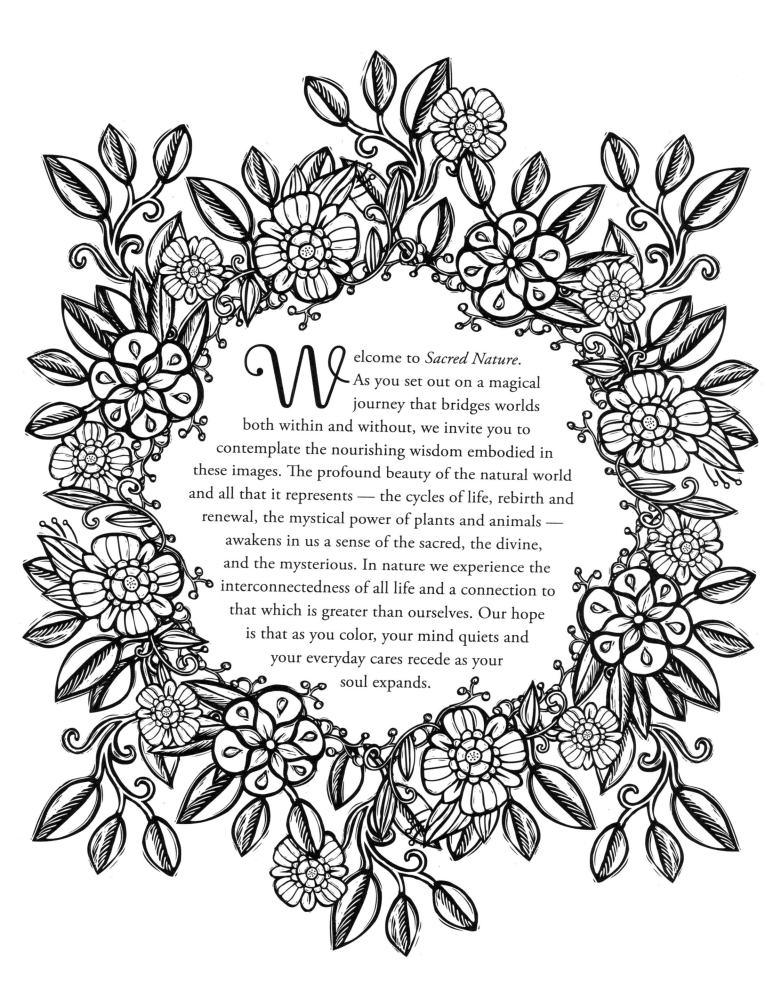

Welcome to *Sacred Nature*.
As you set out on a magical
journey that bridges worlds
both within and without, we invite you to
contemplate the nourishing wisdom embodied in
these images. The profound beauty of the natural world
and all that it represents — the cycles of life, rebirth and
renewal, the mystical power of plants and animals —
awakens in us a sense of the sacred, the divine,
and the mysterious. In nature we experience the
interconnectedness of all life and a connection to
that which is greater than ourselves. Our hope
is that as you color, your mind quiets and
your everyday cares recede as your
soul expands.

Beginnings

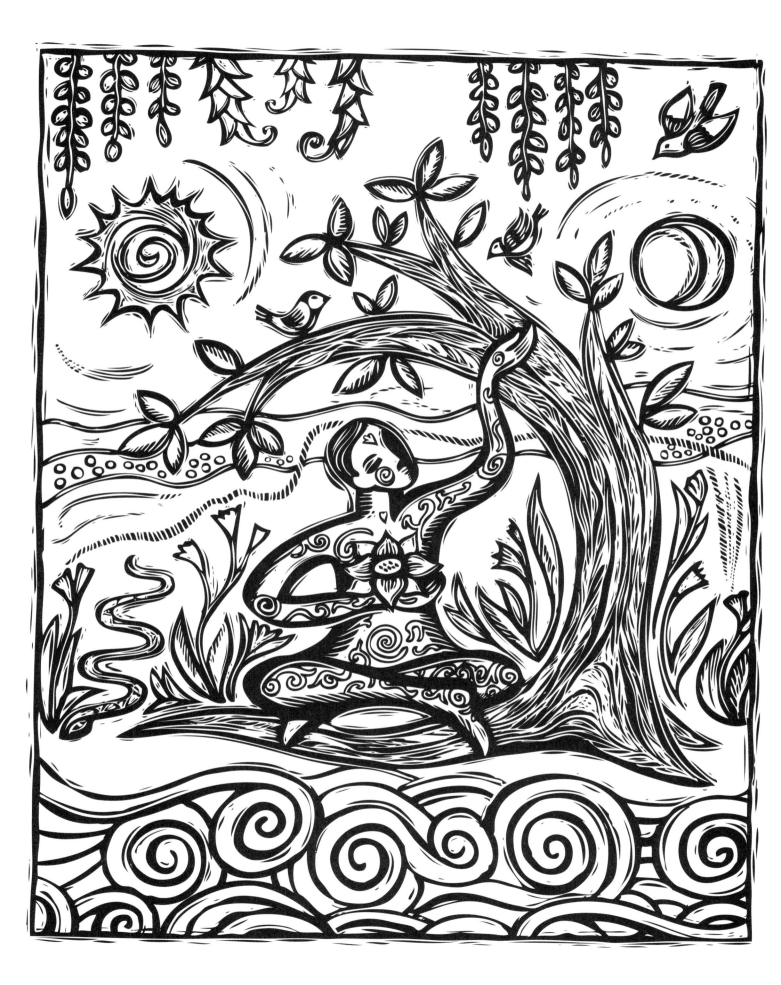

Metamorphosis

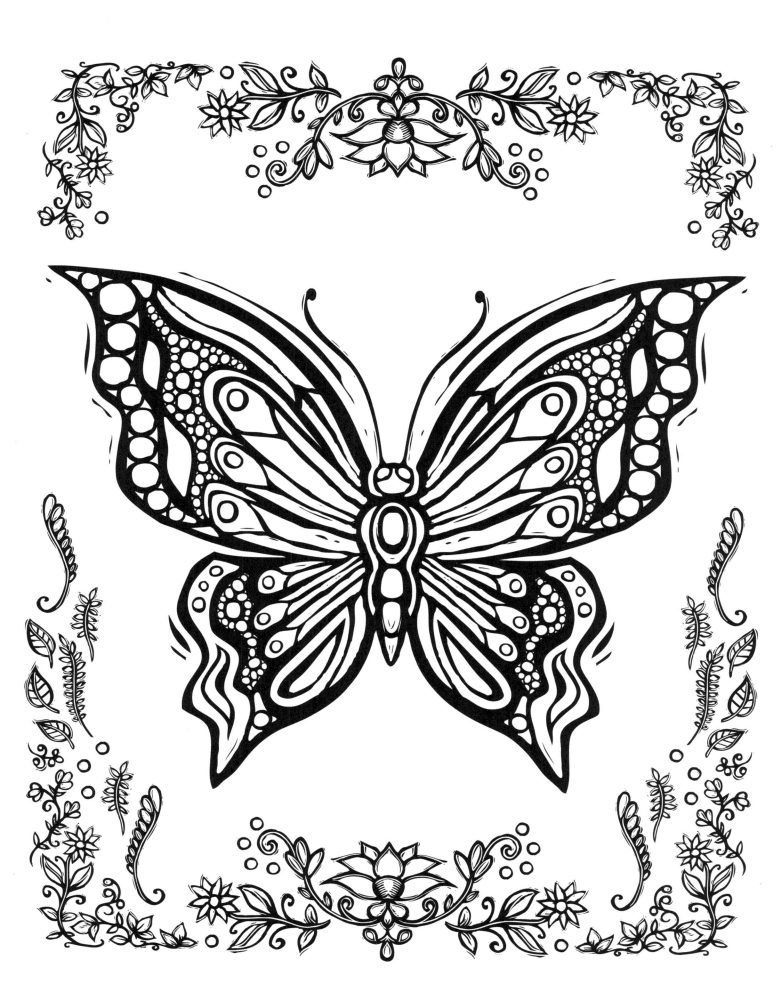

stillness

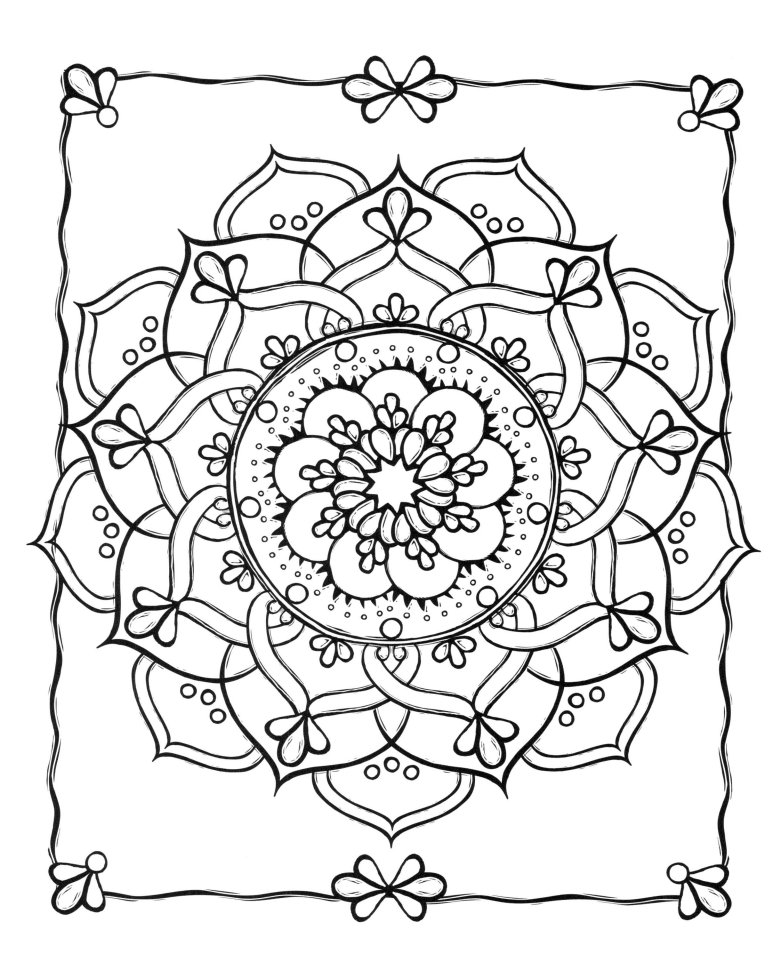

Sustenance

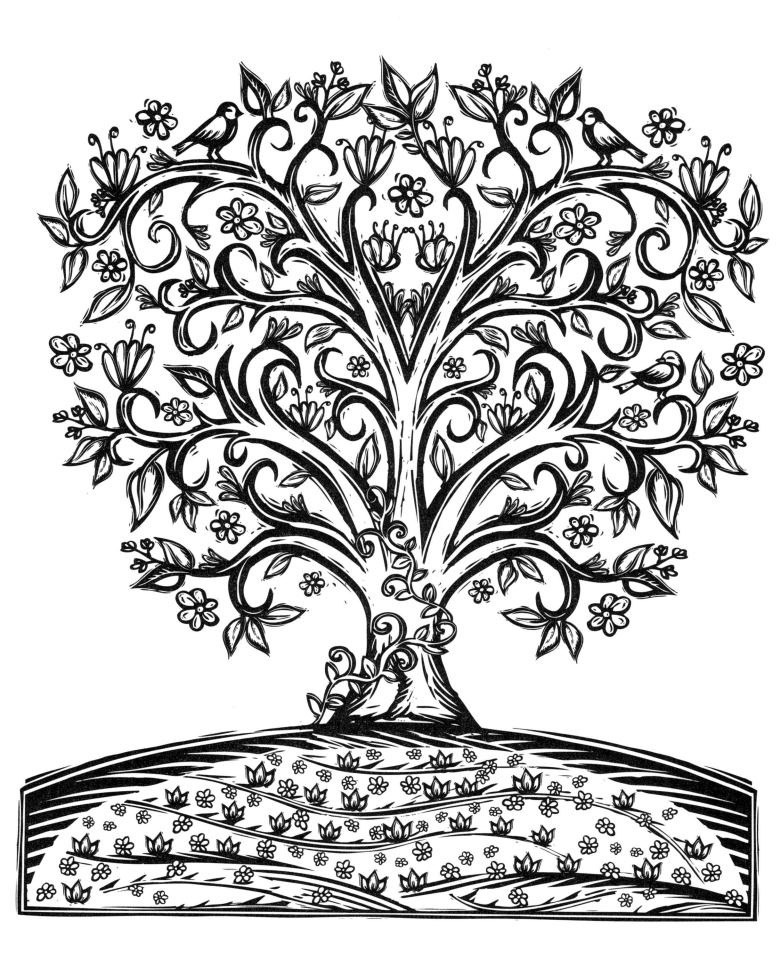

Quietude

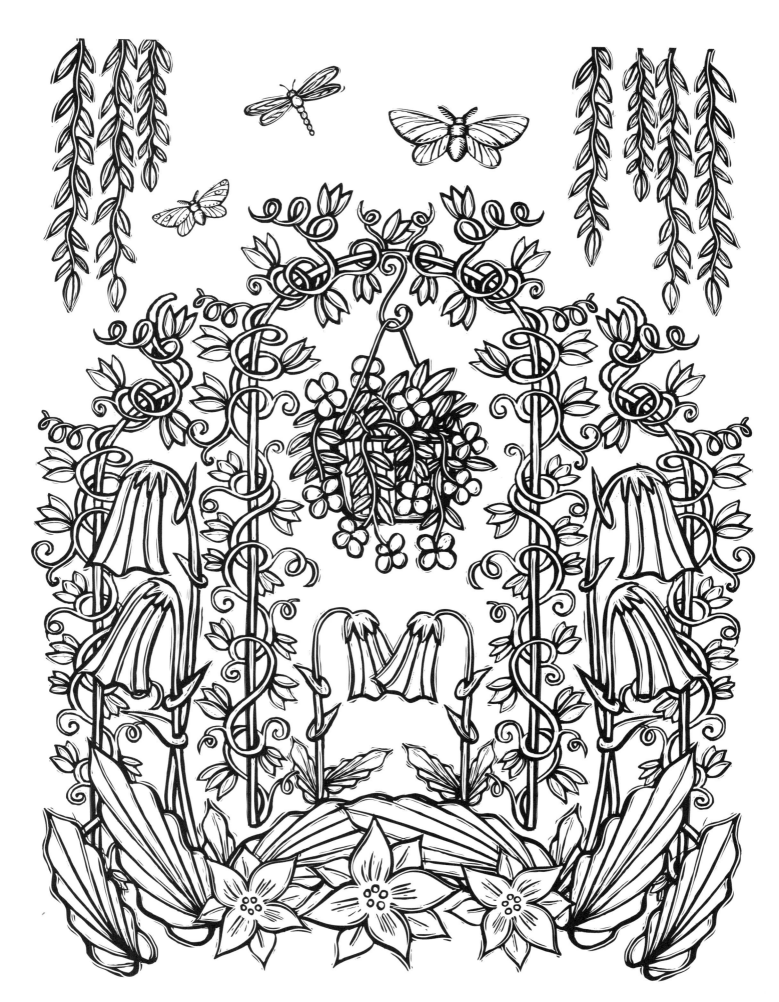

INNOCENCE

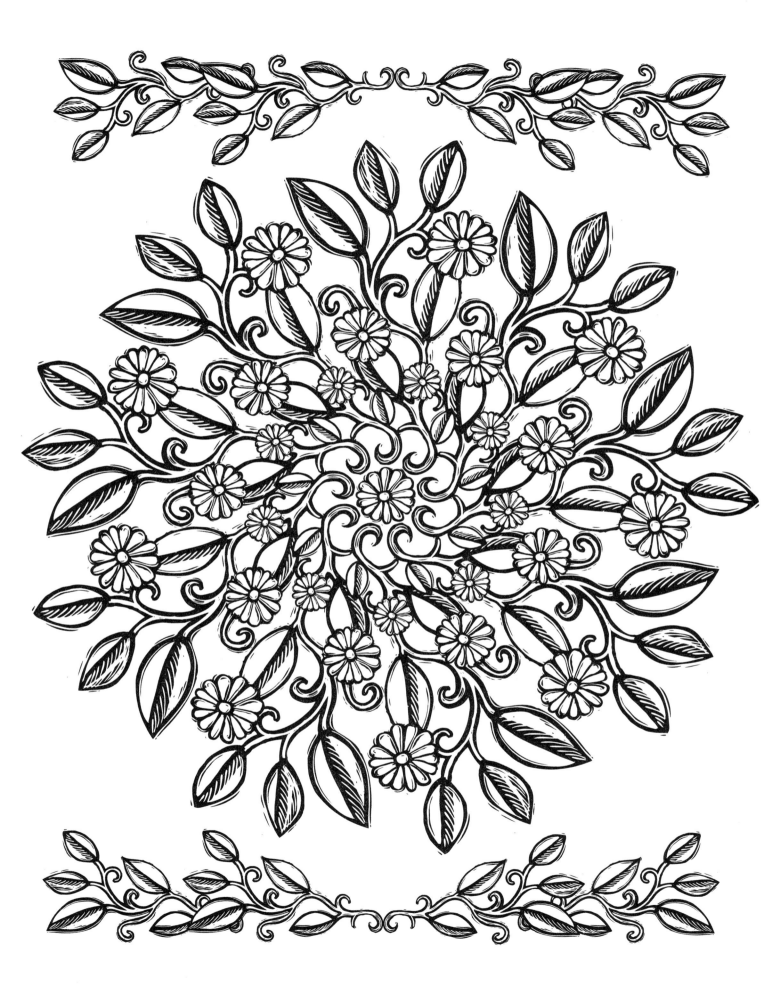

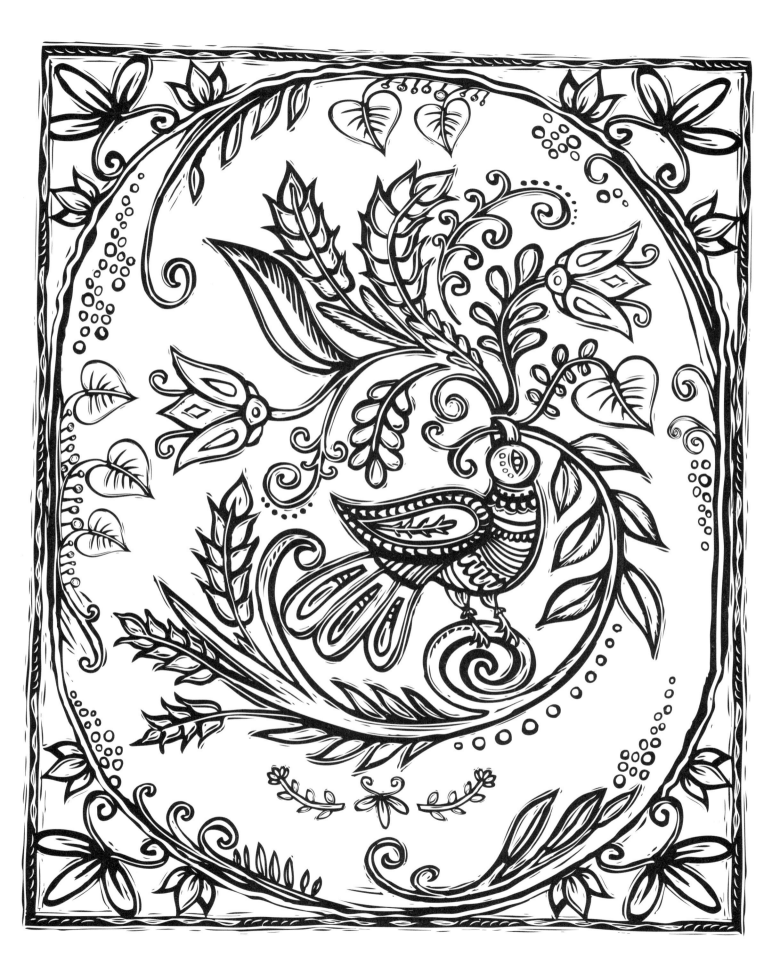

Emerge

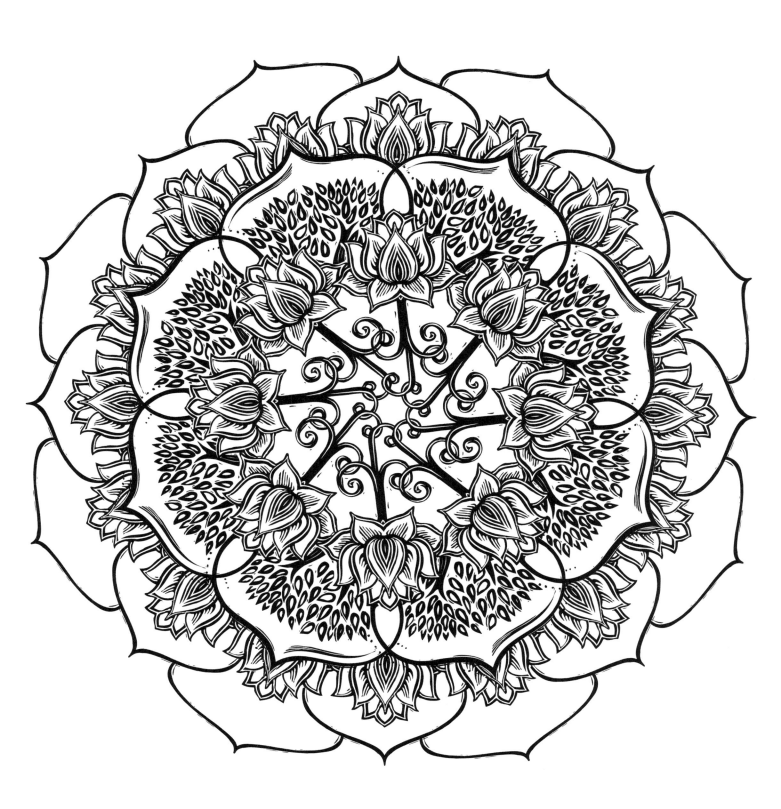

Contentment

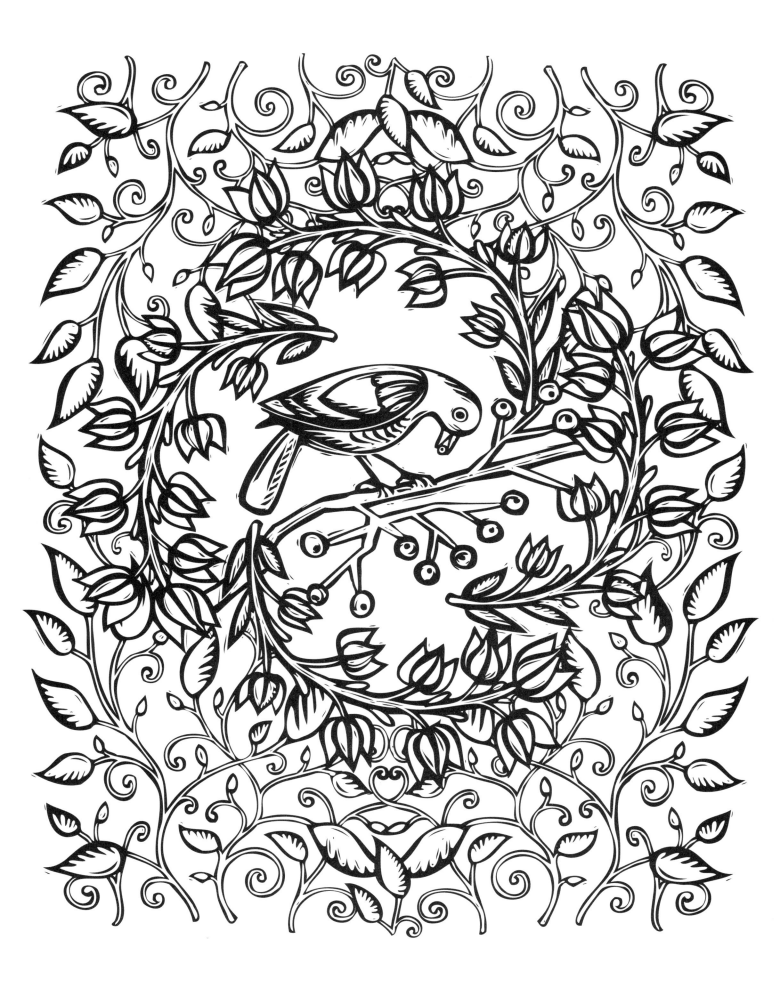

Radiance

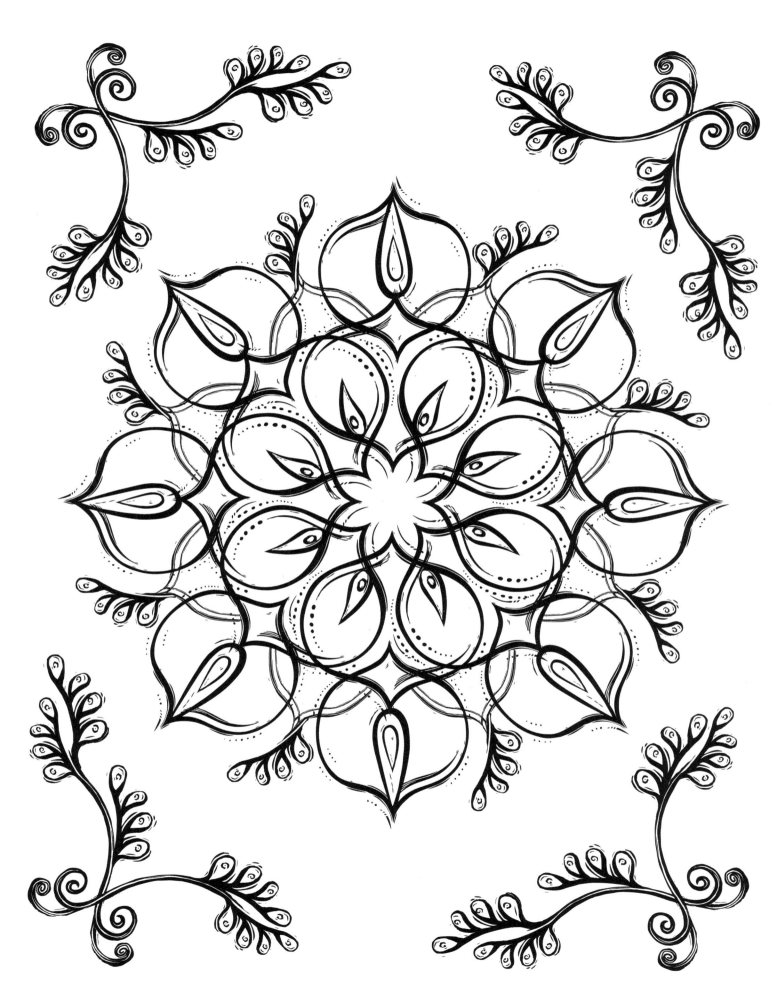

Transform

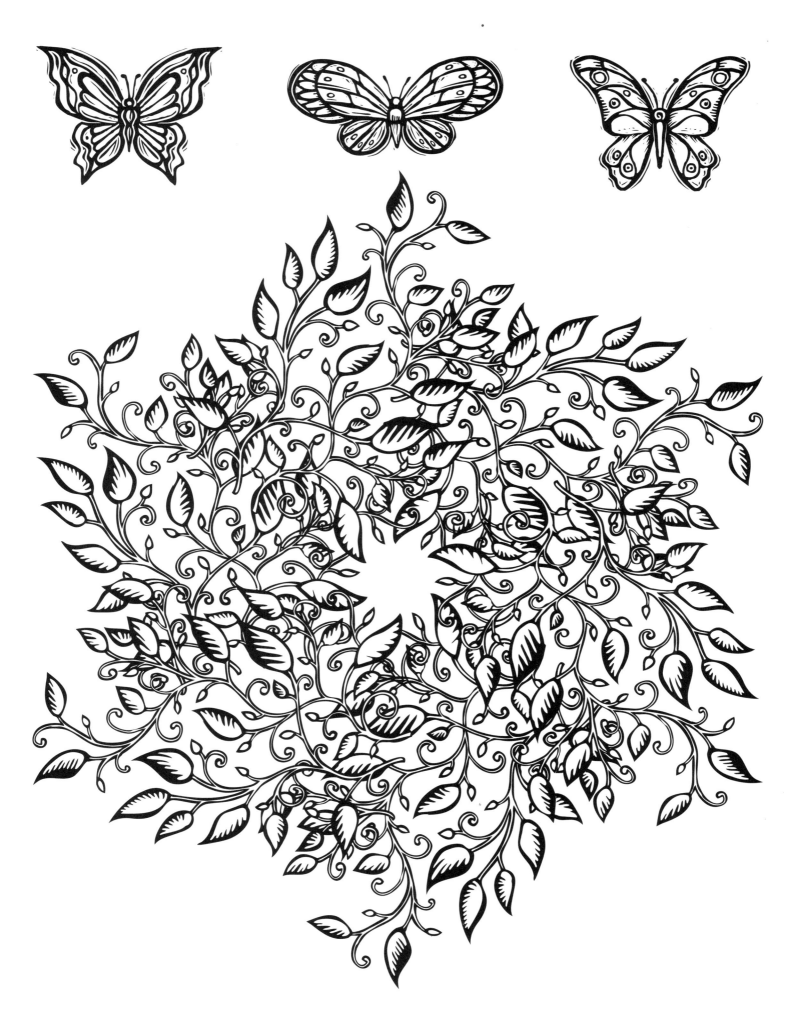

Bountiful

SOURCE

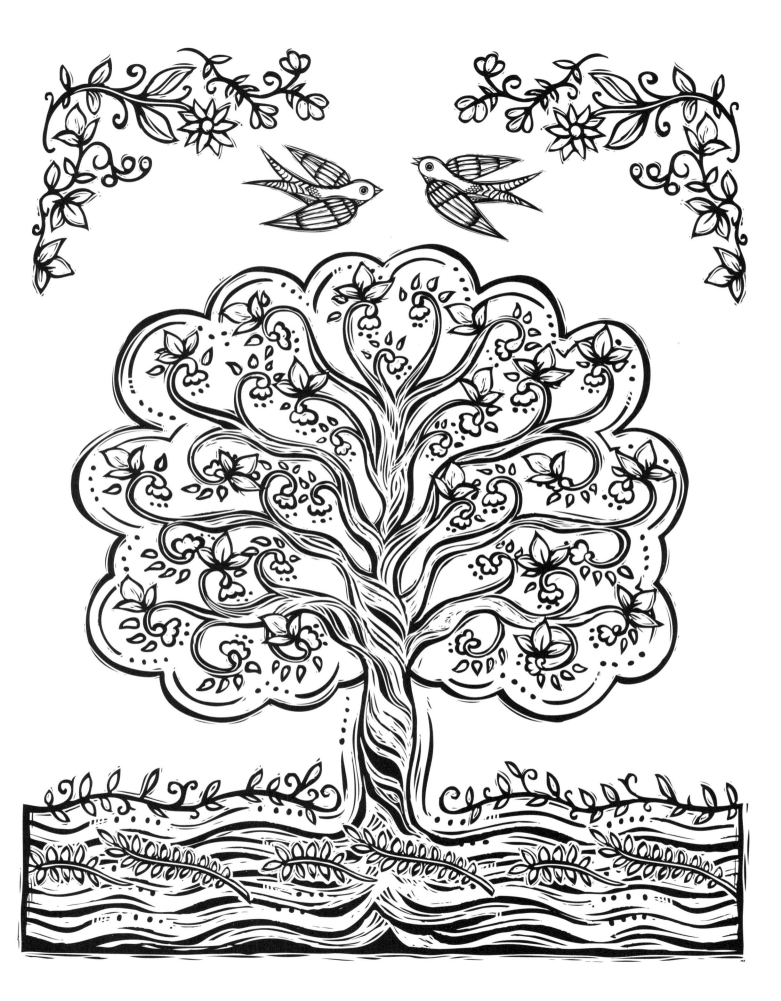

Joy

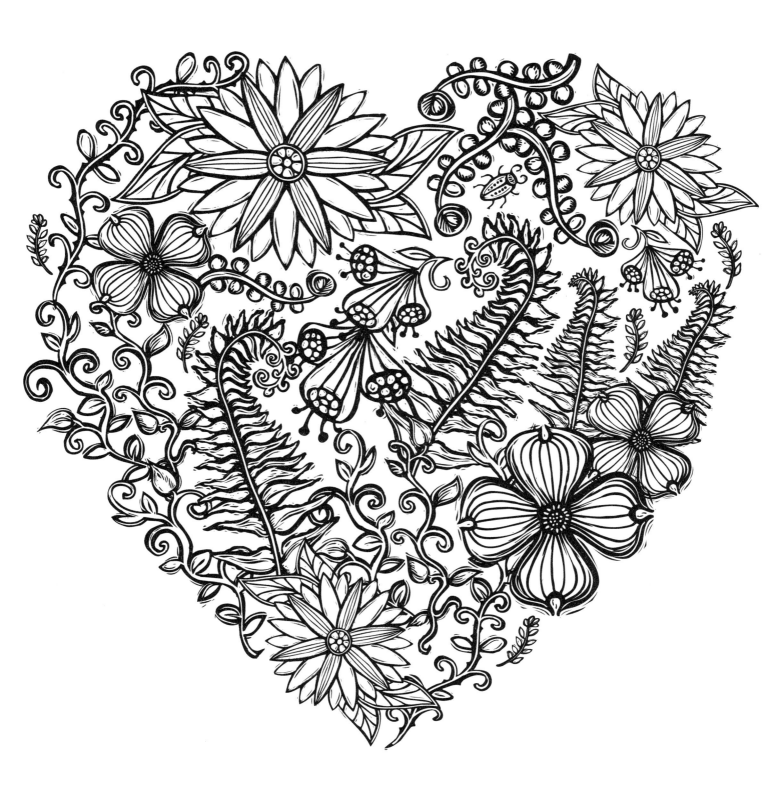

Bloom

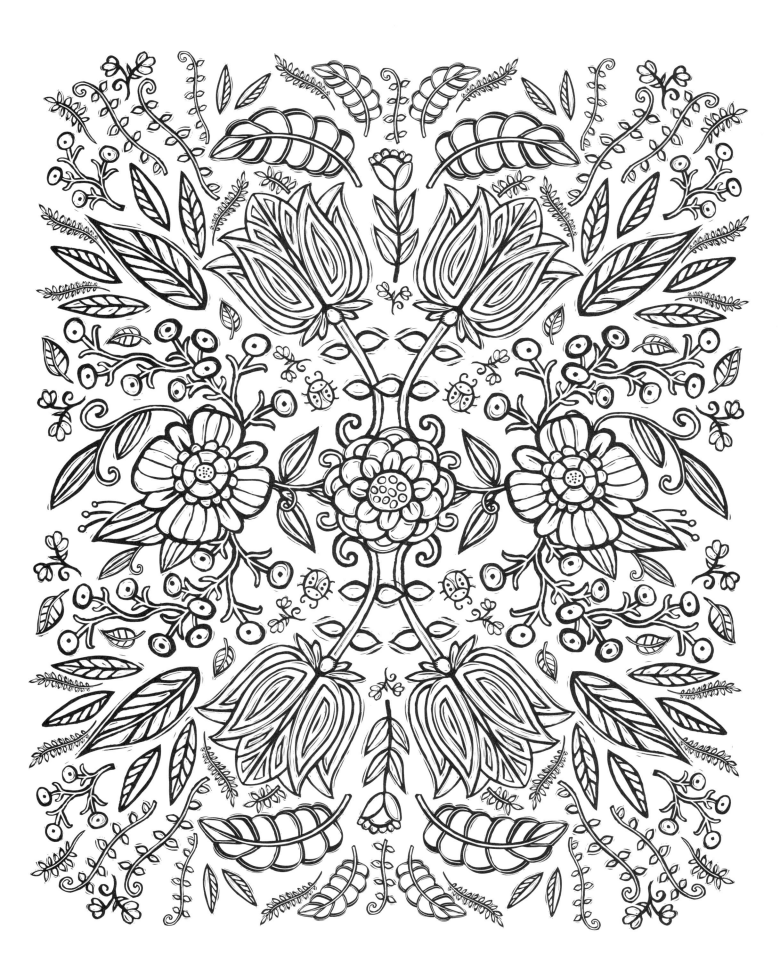

Flourish

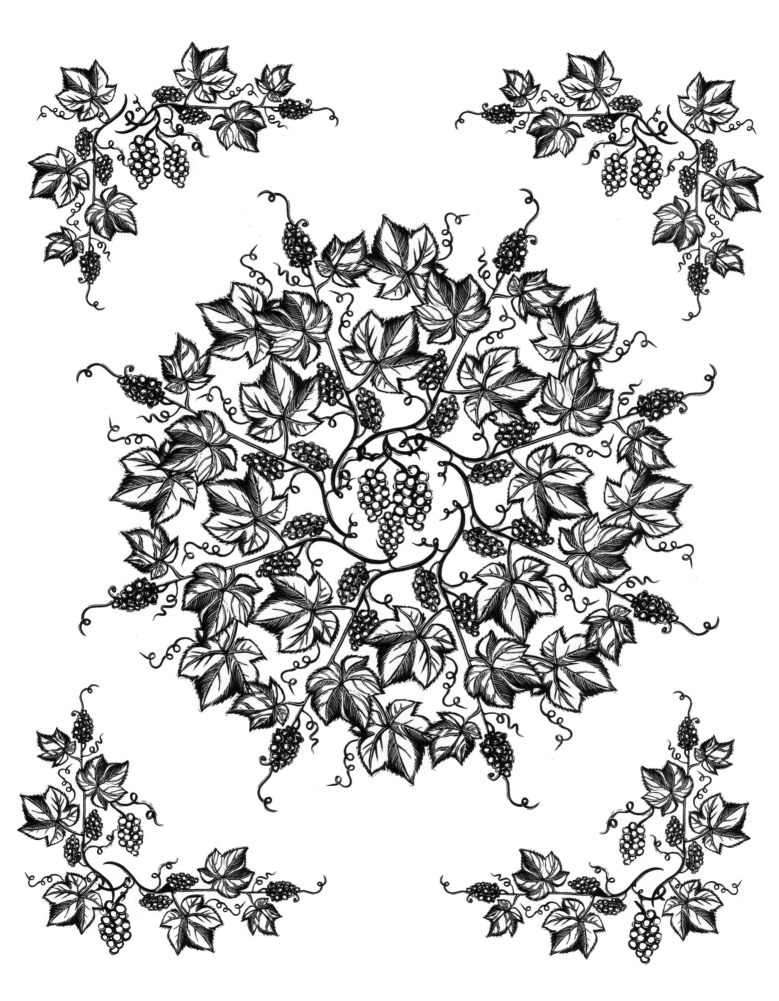

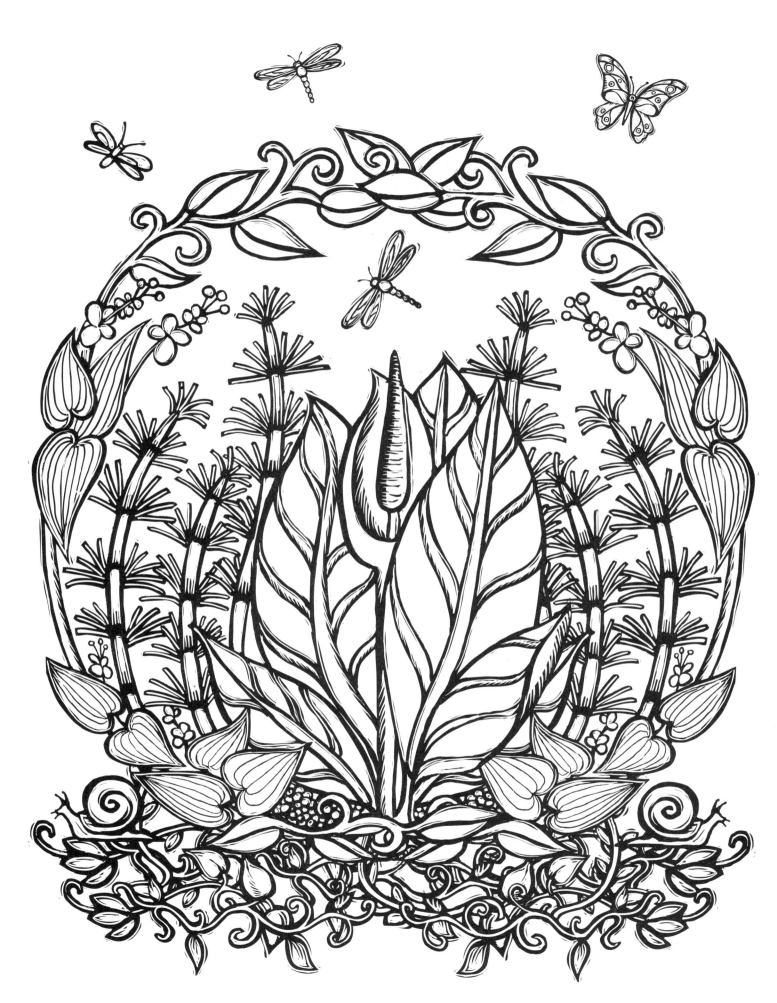

WISDOM

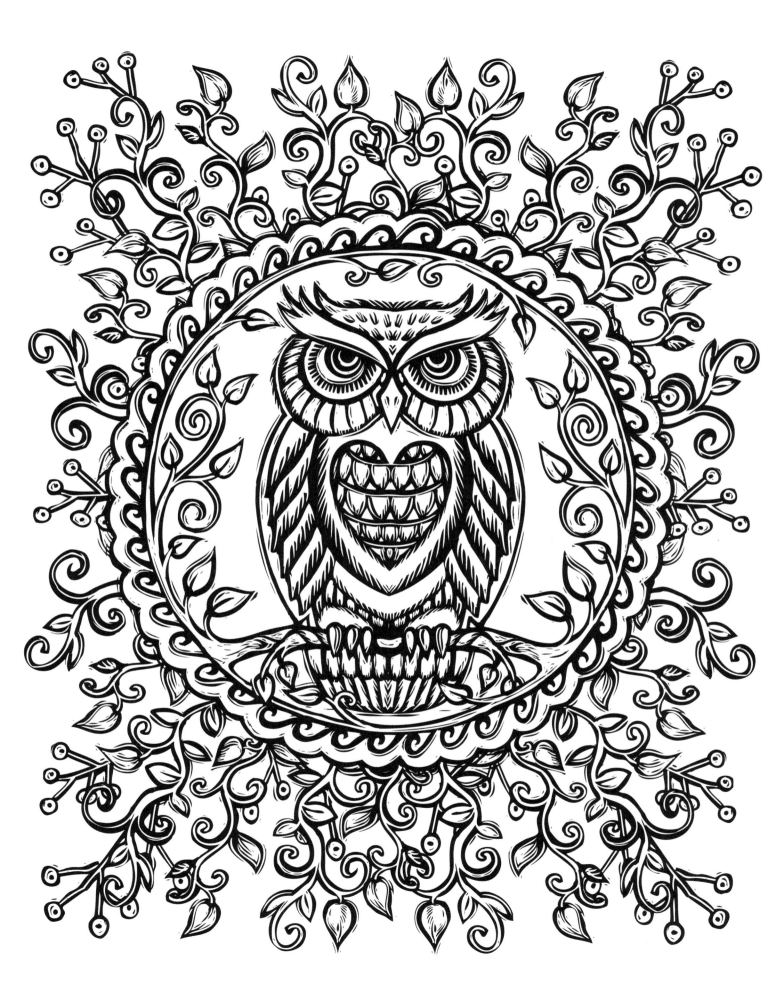

Energy

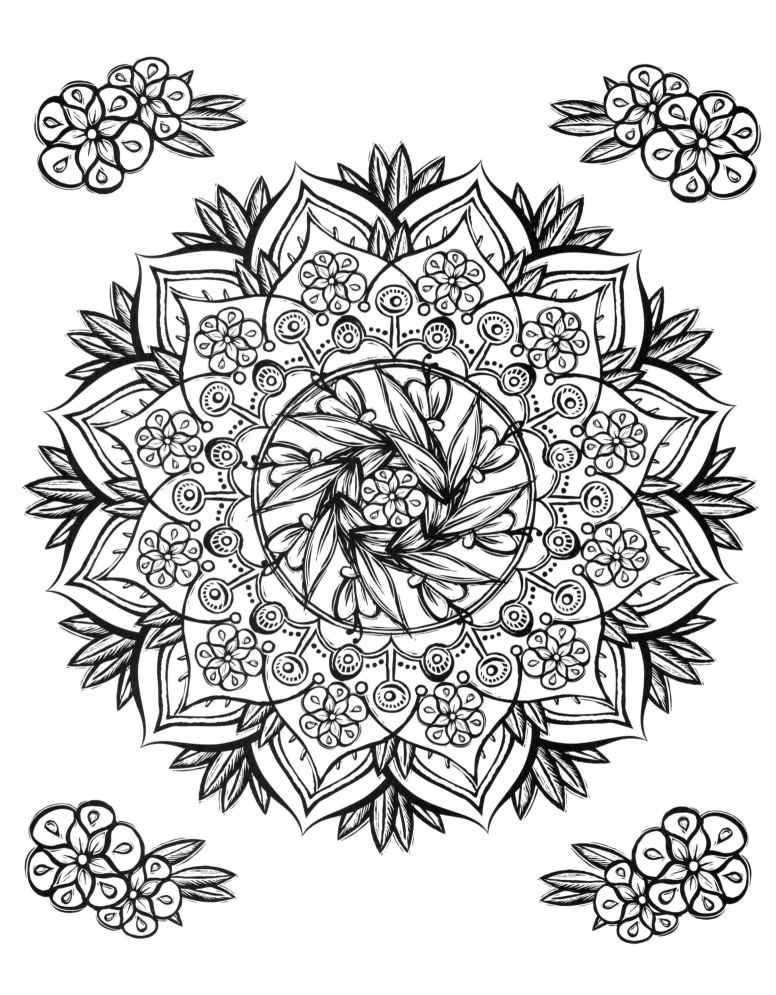

PLAY

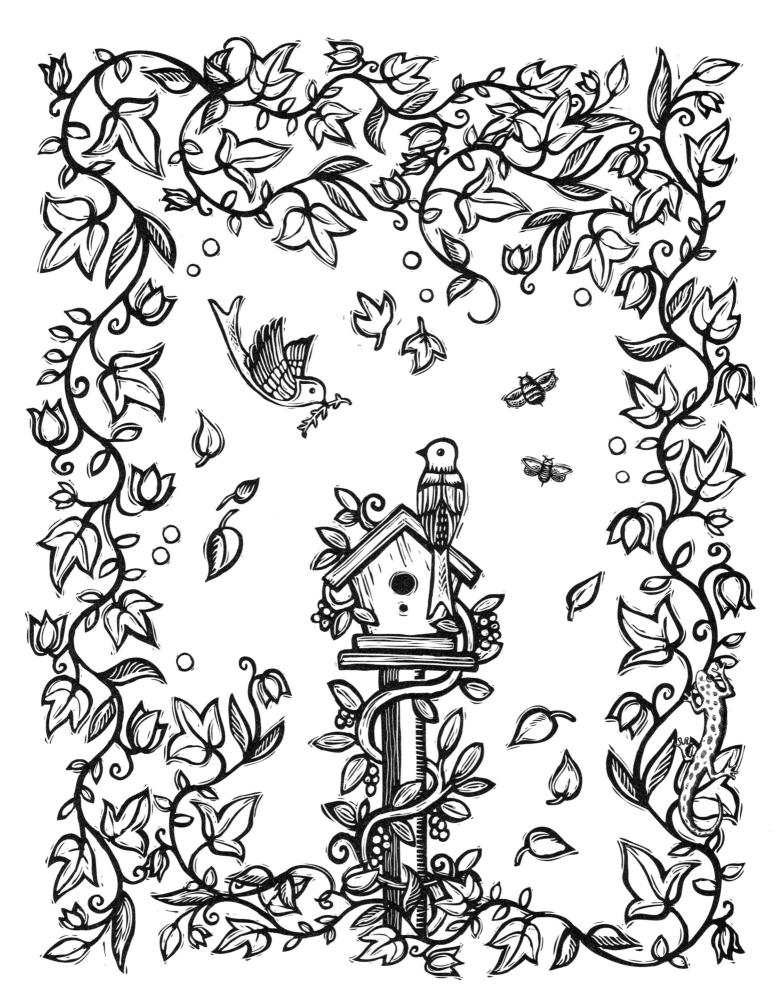

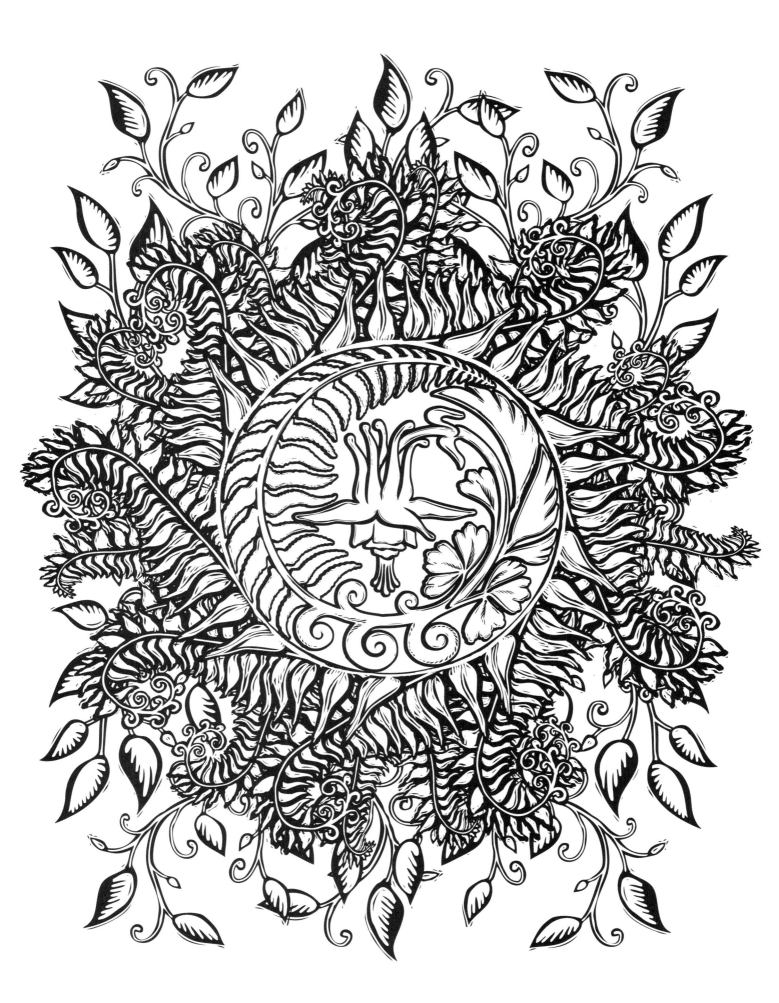

Integrity

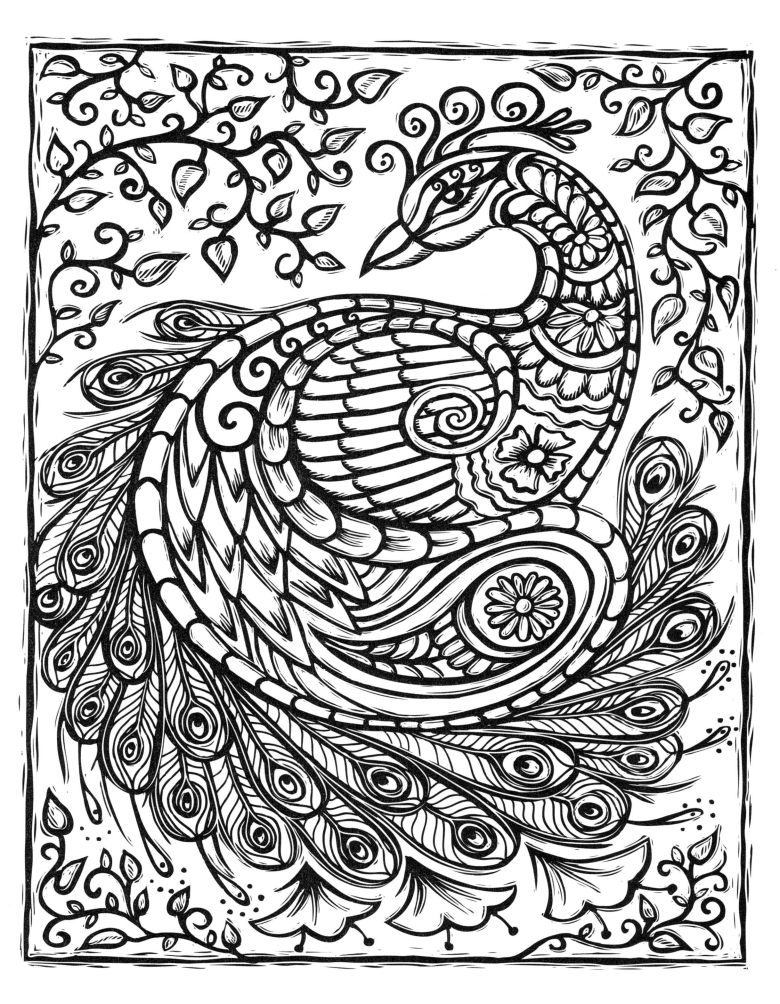

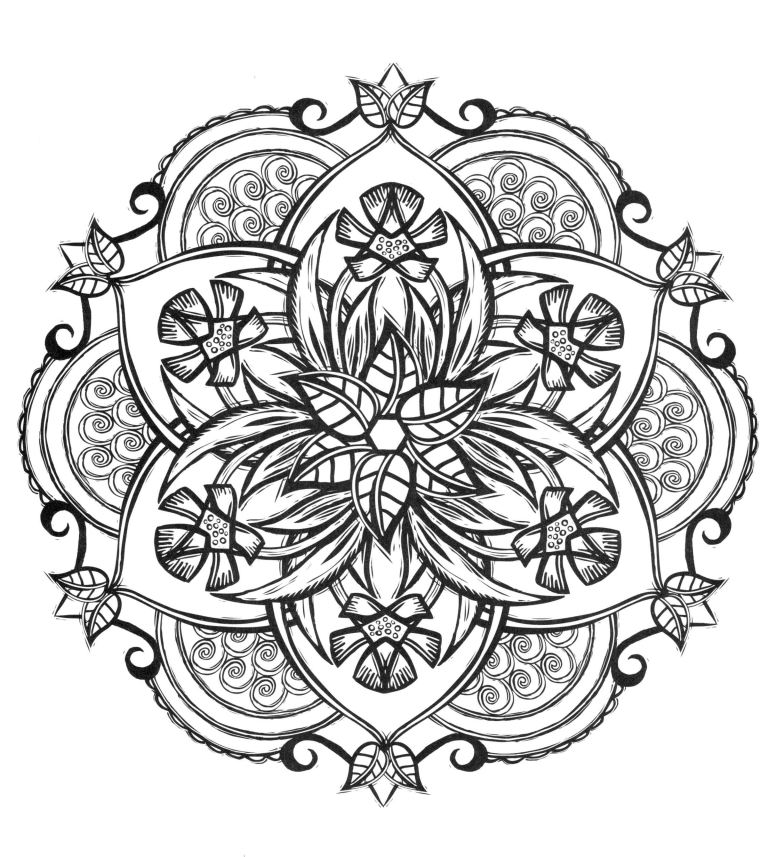

Serendipity

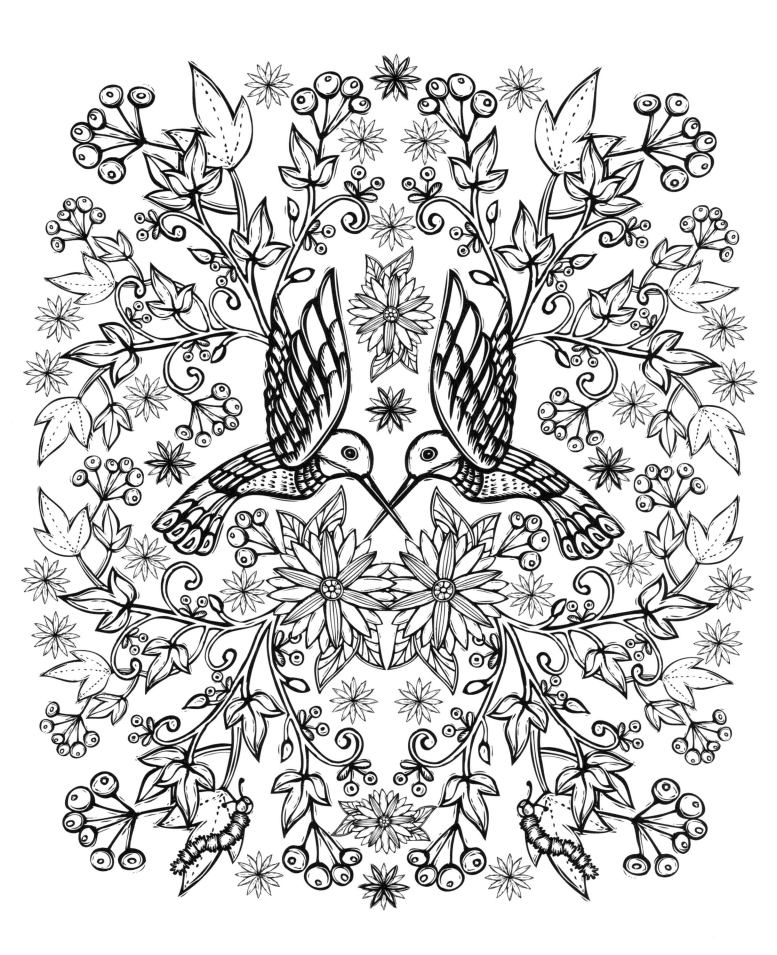

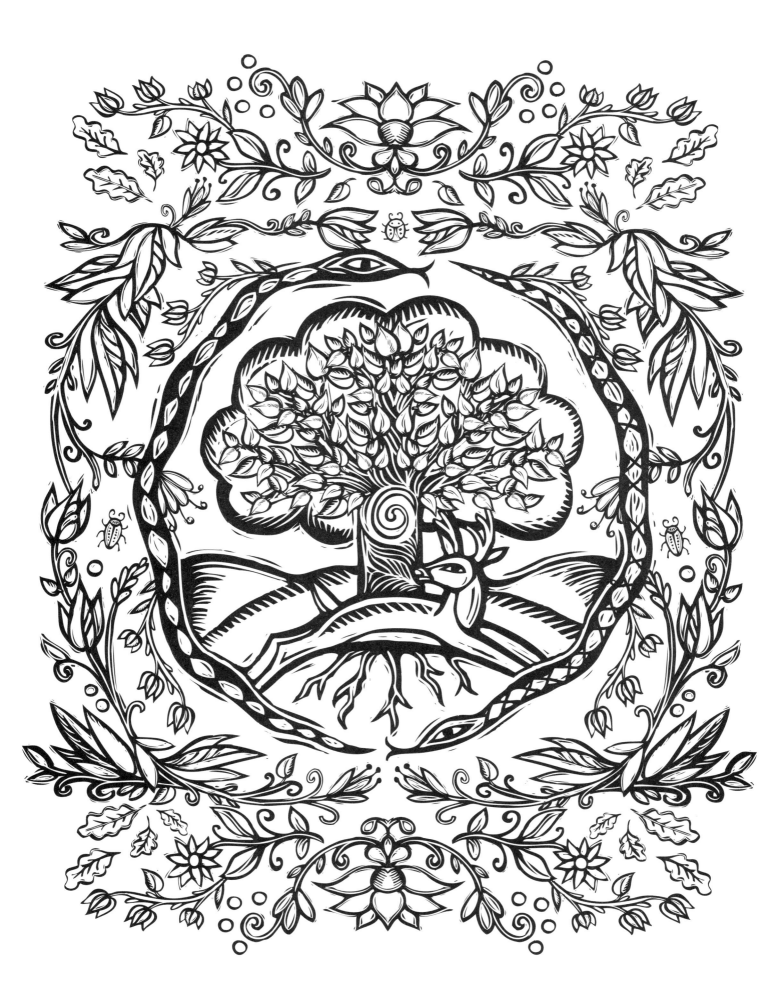

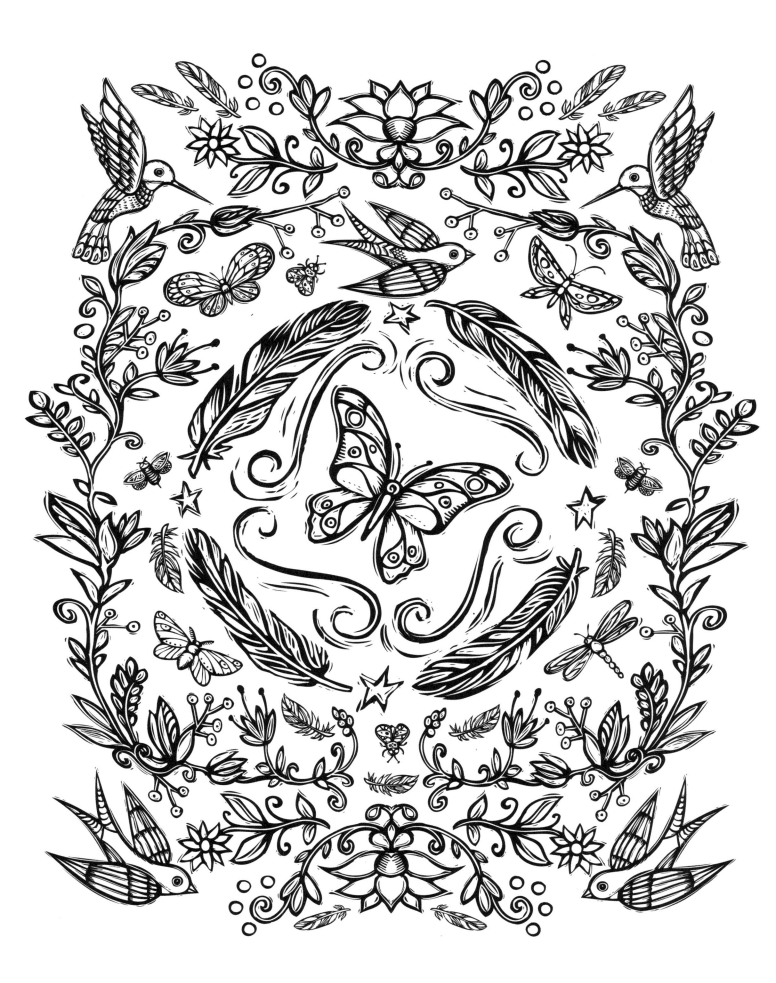

Rebirth

Discover

Grounded

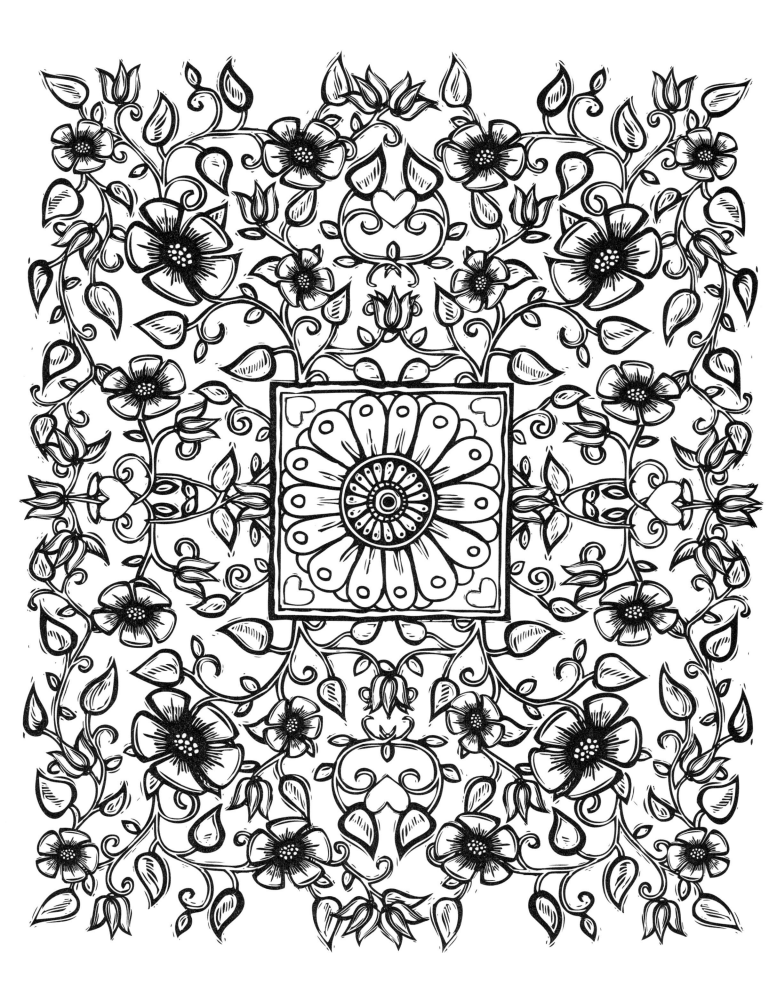

Wondrous

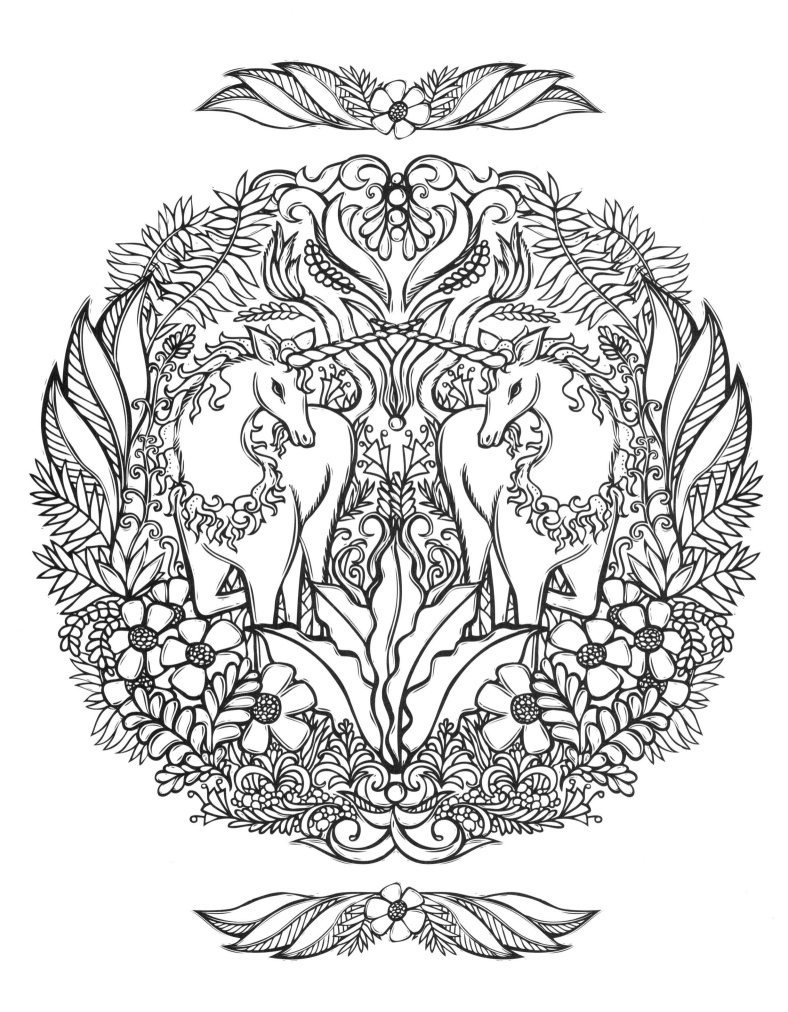

Wild

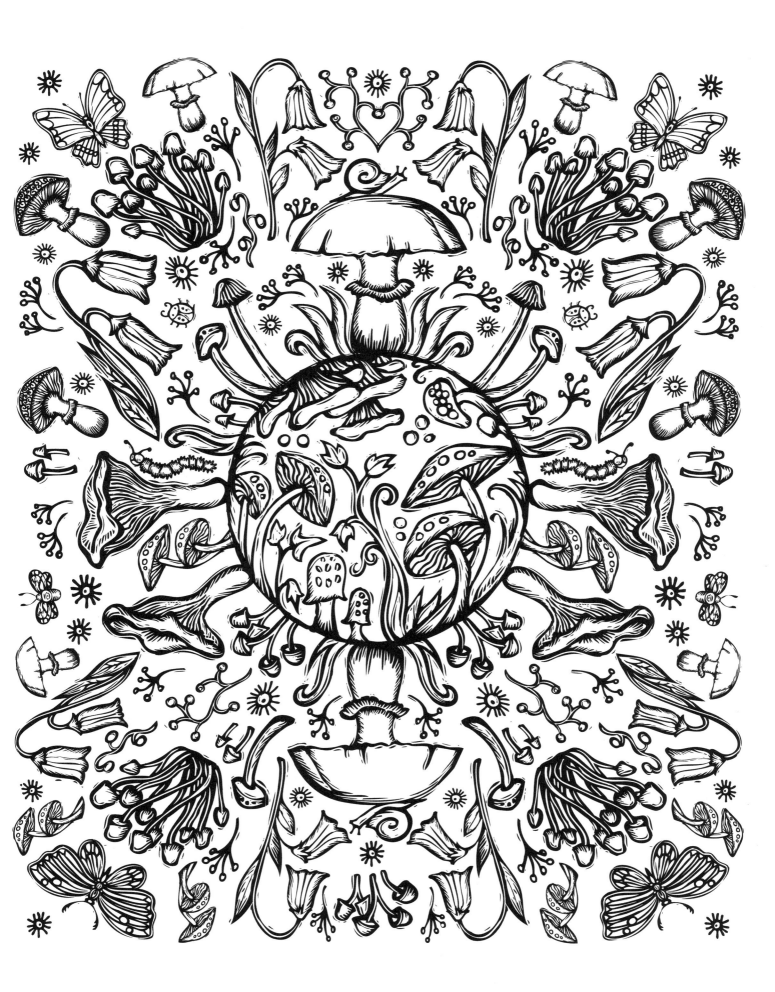

ABUNDANCE

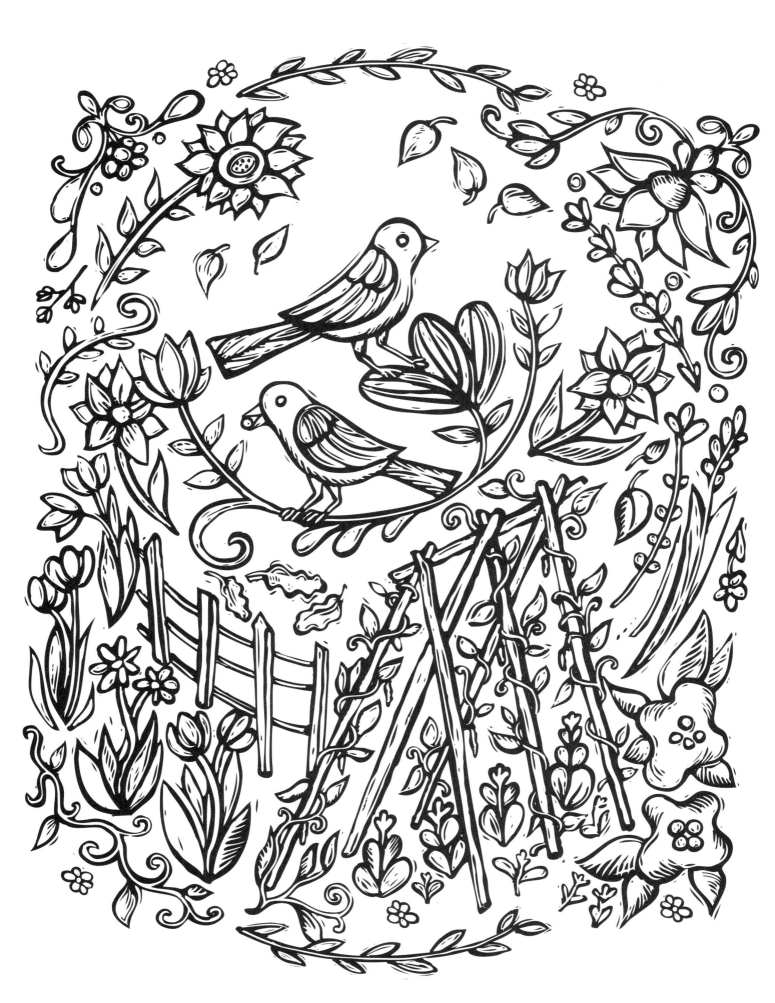

Possibility3

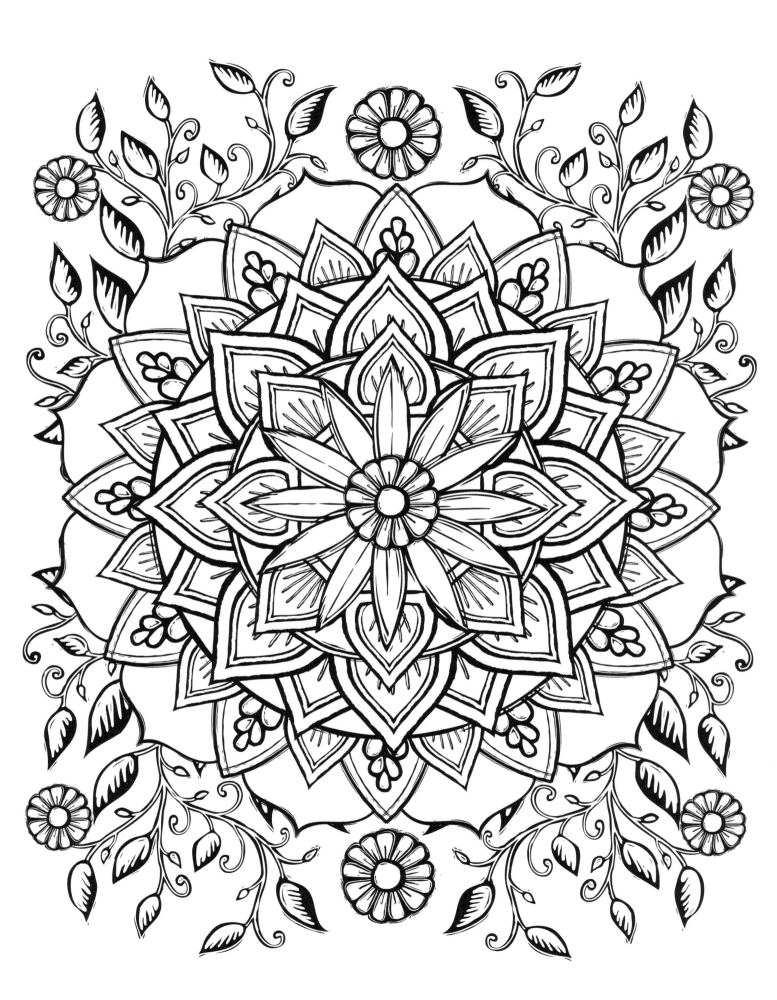

Regeneration

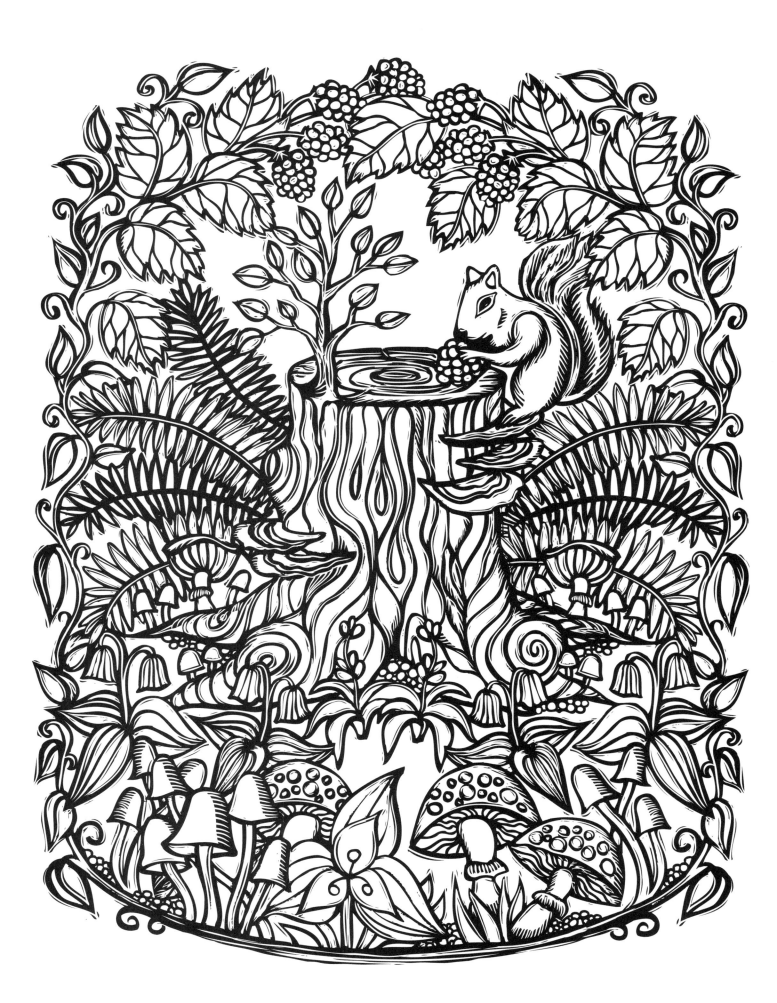

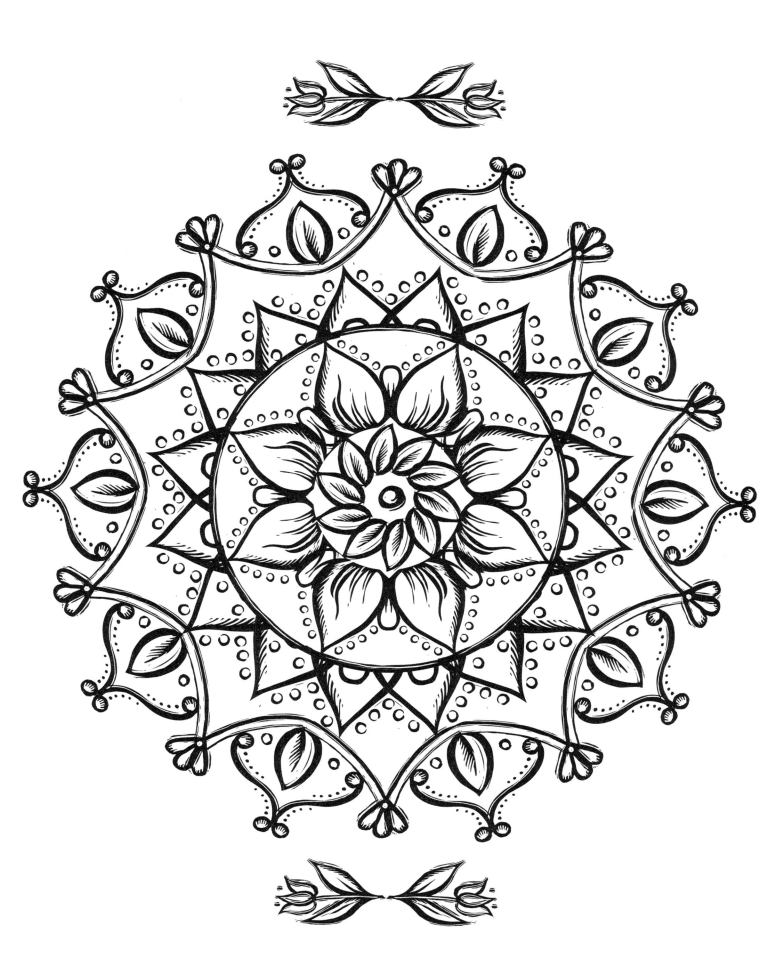

Connection

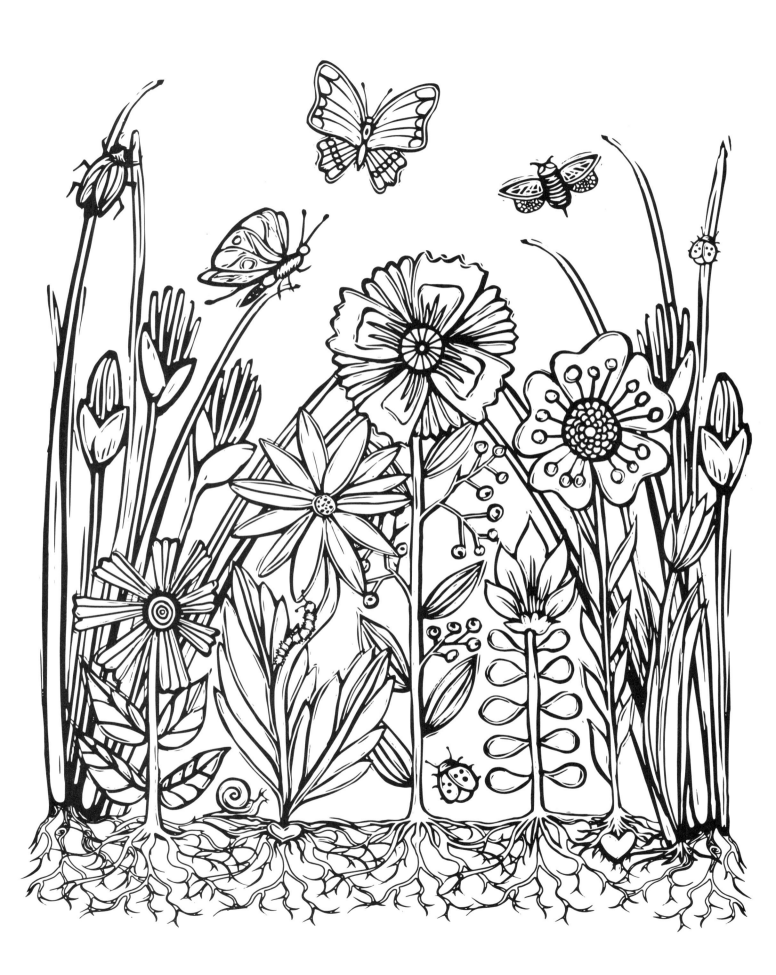

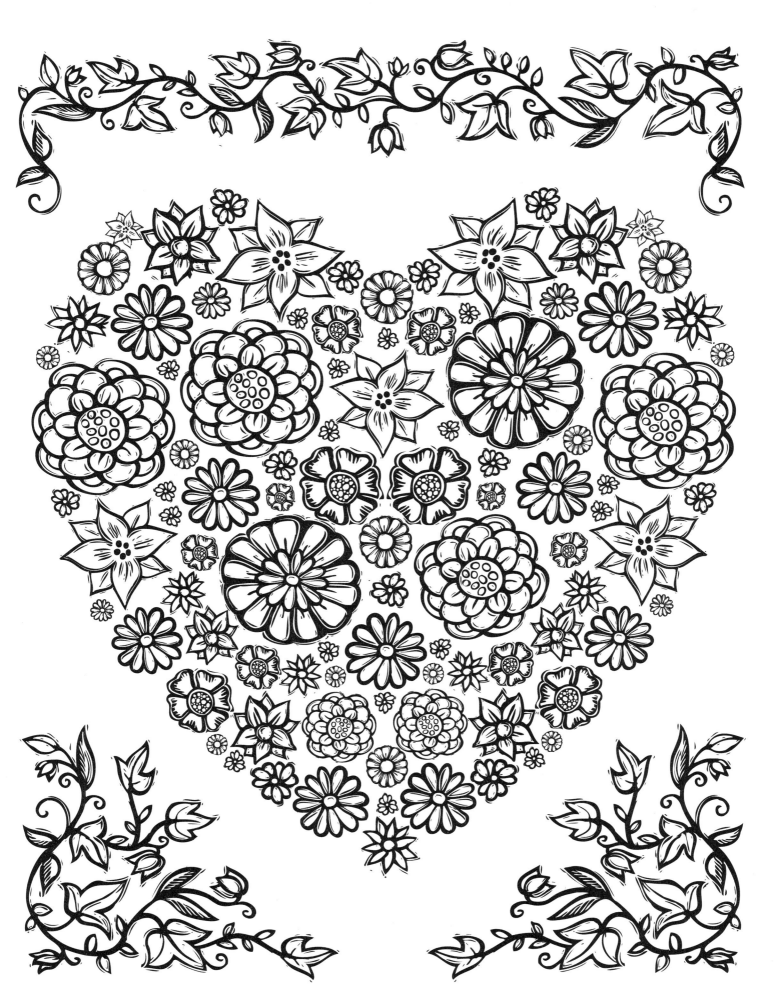

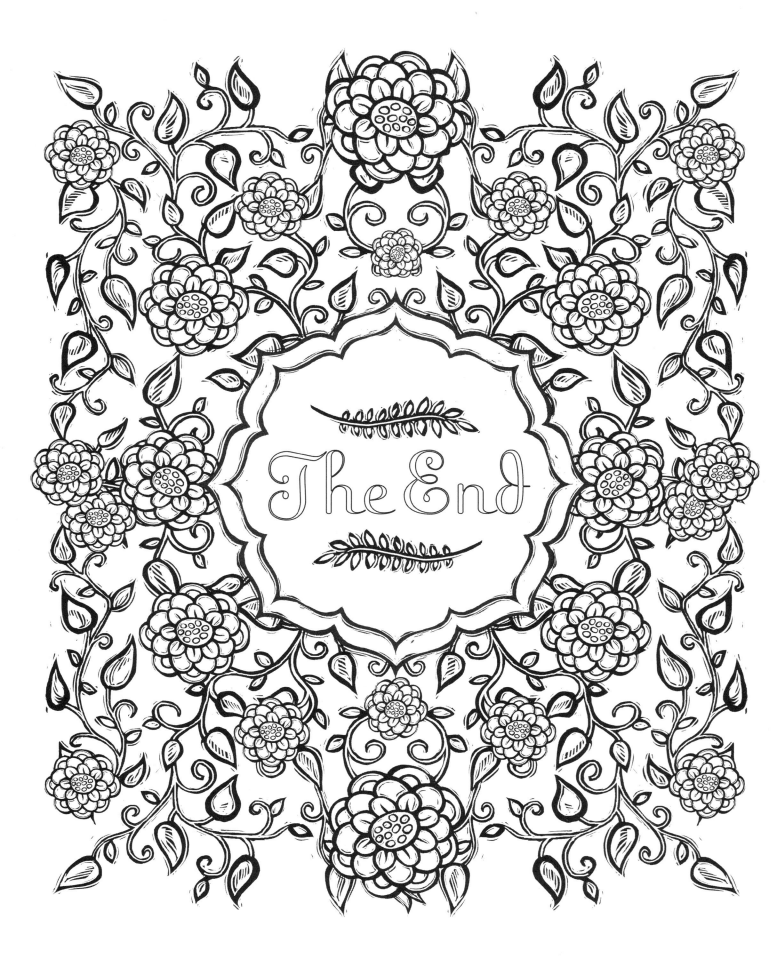